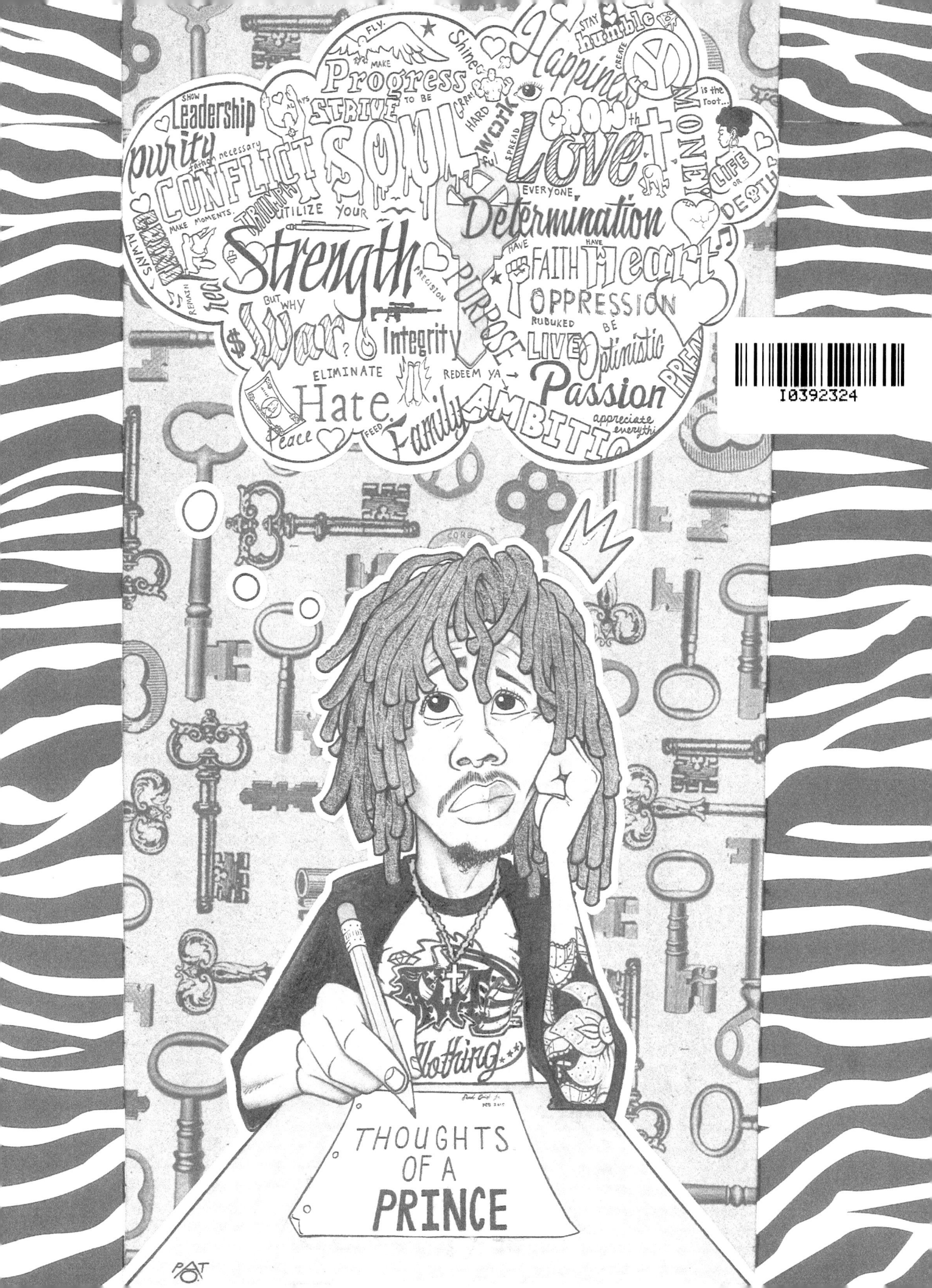

Thoughts of a Prince

Written By:

Ja'Quintin Means

Illustrations by:

Colby Collins and

Patrick Onuigboo Jr

Photography by:

Chauncy Neumann

Edited by:

Angeline Karigan-Winter

Preface

As I stare at the mirror, I wonder if I truly exist. Thoughts of heaven and hell, life and death race though my mind. These thoughts force my heart to beat faster and faster with each breath, as if death were chasing me. The images of guns, drugs, and violence parade through my imagination as the void of darkness and misunderstanding grasp my very being. Is this what life truly is? Is there nothing more than the sounds of gunfire in the once peaceful summer afternoon, followed by the sirens of a police cruiser rushing to discover another concrete victim? Is there a future for a young soul thrust into a world of suffocating hopelessness and death? The year is 1997, and I am six years old living in the amazing city of Hot Springs, Arkansas.

My earliest and most vivid memories are those spent in the projects of downtown Hot Springs, where drug dealing and baby making is a way of life. Where the fear of the police is an understood notion, and the hope of a better tomorrow is always two steps out of reach. My only sense of peace is the warm feel of my grandmother's home. The scent of her full-flavored basic 100's fills the living room as we read the morning paper and drink coffee together. The morning sun reaches the plants on the windowsill and it's time to start breakfast. The only chance I am able to convert to my adventurous and pure soul is by pretending to be a commando on the bedroom floor, while granny sits in her rocking chair and works on Mrs. White's alterations for her new summer pants. I go outside to play and pick fresh pears off of Mr. White's tree, seeing newfound curiosities awaiting me around every corner.

That is, until the oh so familiar sounds of tires screeching and a thunderous pop force me back into the house and remind me of my harsh reality. The questions of why were explained only as "God's plan" in the stories they taught in Sunday morning Bible study. Granny always made me go to church with her, and we always had to be there early. There was nothing she loved more than cooking for the church and listening to my teacher brag about how well I memorized the Sunday scripture and how impressed she was at how I understood the lessons of the old tales.

Even though I heard the preacher preach and knew the words all too well, nothing in church ever explained why I was cursed to live a life in such a world. Or why I was here at all. I began to look up to the sky and ask the tough questions that no one in any area of my life could answer. It didn't matter if they were a homie on the street, or the preacher in pulpit, no one could answer with truth and honesty.

This is not suggesting that I have discovered the answers to all-powerful wisdom.

This is not a book claiming that I am anything other than a normal human being just like you. This is a simple collection of my journal writings that contains various essays, poems, random thoughts, and short stories. I am sharing this with you, the reader, to express something from my heart to yours. To share that when I looked up to the sky and asked my questions, I didn't always hear a voice, but I always got answers. So, walk with me as we take a journey through the thoughts of a boy who first learned to be a man, and then transformed into a prince.

Intro

Before we get started on our journey through the thoughts of a prince, let me give you a little insight about myself. My name is Ja'Quintin Means. I am 24 years old, and I was born and raised in the beautiful natural state of Arkansas. In my short time in this world I've had the pleasure of working and serving in positions of leadership. One of those positions was as a minister in training and youth pastor in the Methodist church. The way things fell into place for me to hold such a position right off the streets opened my eyes to a more divine plan for my life.

The events that led up to that point affect me even today. In my life I have faced racism, loss of loved ones, homelessness, low self-esteem, and I haven't even started on my faults. Through witnessing my life unfold and the beauty of the unknown, I began to seek truth outside of the church. So I left all of it behind in order to stand for something greater than the constructs of religion. I felt the need to stand for justice and love rather than separation and confusion. Throughout my life I've been sensitive to the world around me and what people thought about their existence.

Section 1

Age 17

Finding Your Way
2009

What do you do when you put your heart and soul into something you cannot achieve? Do you stay with it because you love it? Do you keep doing it for enjoyment, or do you quit? I'm at a loss here. My head tells me that I should quit while I'm ahead. Rethink my strategy and throw in the towel. No one will call me a quitter, but how will I view myself? When I started on my journey, I said I would give it all I have, no holding back until I had reached the finish line. That no matter what place I come in I would still be a winner. Do I believe the impossible and go for it all, or do I watch from the sidelines like those around me?

No!!!! I refuse to accept defeat so early. My goal will remain. I cannot stop. I'm so close, I can feel it. I can do it. I will do it. I will give it every ounce of my will, and I will do the unthinkable. I will prove myself wrong and those who ever doubted me. As I've said before, "shoot for the moon and even if I miss, I will still be among the stars."

Thoughts of a Prince By: Ja'Quintin Means

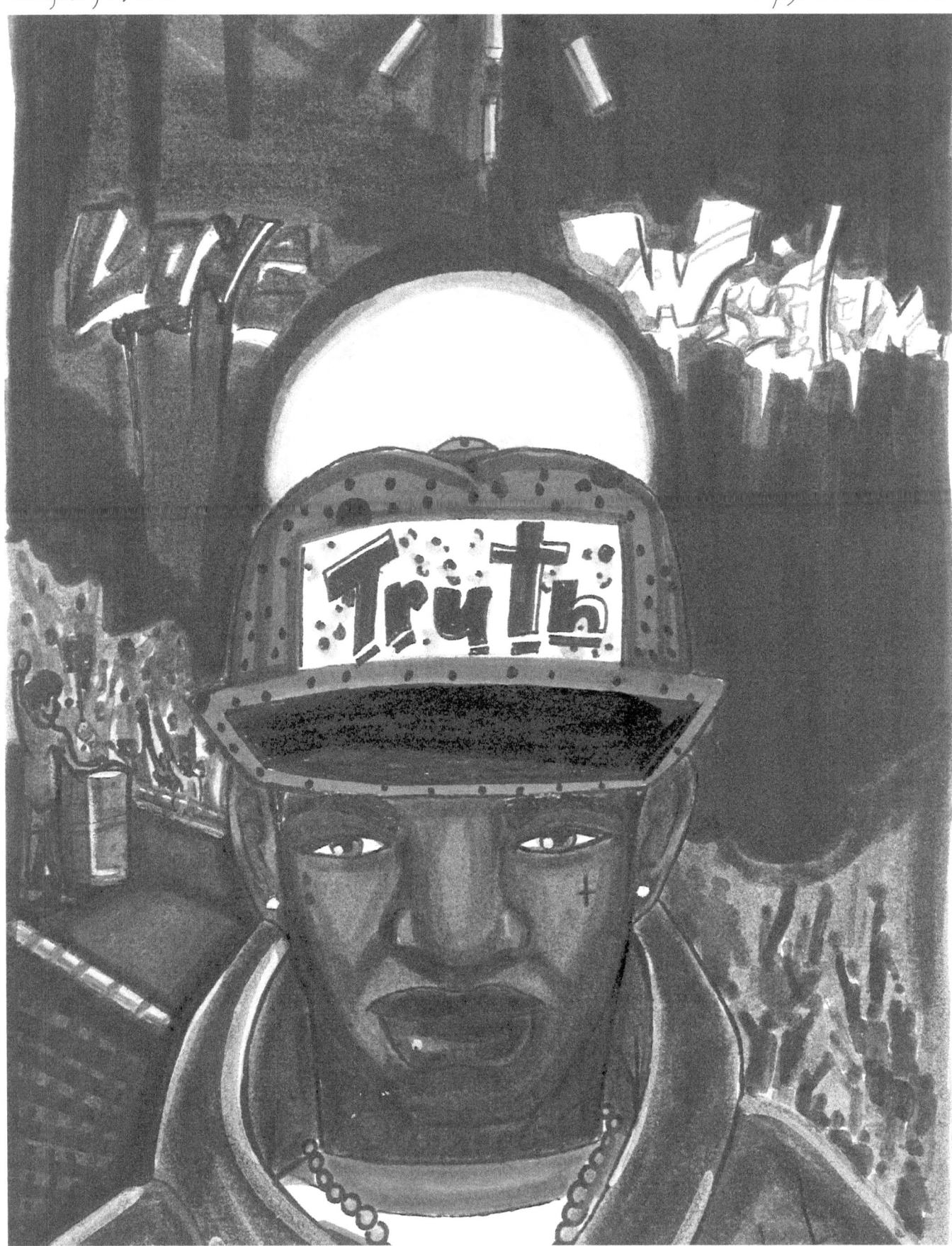

In Memory of

Twon

6/09

Life experiences are what truly separate the greats from the ordinary. It is easy to see things happen and believe that you understand what a person is supposed to feel. It is another thing to experience it. It seems to me that the Creator chooses the great ones. Spirit tests their faith time and time again through loss, be it money or a loved one. The reason I believe this is because it is impossible to lead and to teach if you have not gone through tough experiences yourself. Spirit gives us a choice. Either you can ask why a thousand times with the hope that someday you will find the answer, or you react thoughtfully.

You learn to take the situation and realize that it is all a part of the Creator's plan. There are some of us out there that will choose the latter, and these people are truly great. These people lead us into a better tomorrow. I will be one of these people. I will touch many and change this world we live in, not because I want to or because I should, but because I was chosen to do so by our spirit of love and joy, which is great and mighty. Because it is the spirit's will, and the will of spirit should be manifested through every single person who chooses to shine.

Together my fellow brothers and sisters will start a flame that will change society and create beauty. We, the people of this world, will show everyone and everything that there is good in this side of existence if we just choose to see it.

Section 2

Age 18

The Path

2010

How do you follow a path laid out for you if you choose not to see it? What if you look for it and never find it? If this is you as it is me, do not fear. You can't lose something that has never left. You can only choose to suppress your path. You choose to ask the questions that you already have the answers to, and you are fearful instead of strong. You look in the mirror and you don't see a reflection of yourself. Instead you see a coward, a lost duckling straying away from its mother, scared and confused. This may be you, as it is me now and again. Turn your life over to love.

Let love's wants and needs become your wants and needs. Let the spirit of love guide you on its path that was laid out for you follow. Love this lifestyle, and the rest of the world will follow down that path of peace and grace.

Value of Life

7/11/10

What is the value of life? Is it the price of oil, war, or happiness? It has always been crazy to me that I could pay 100 dollars to have my brother killed, but all the money in the world could not bring him back to life. Life is a gift. It is what turns clay and dust into flesh and bone. Yet, still we try to put a price on it, and sometimes we succeed. So what is the worth of a man? The worth of a man is not in his material belongings, not in his career, not in his children, but in his strength. How fearless or fearful was the man? Was he unafraid to live side-by-side with love and wisdom?

Or did he have little faith and stray away from all he believed in for material gain? What good things did you do? Did you do them for selfish pride and glory of the world? If so you, have your reward in full and be blinded by your own self. Instead, do good when there is no one watching. Those who act justly even when they are confused and pain consumes their hearts, who do good when the world is dark and their enemies surround them from every angle, are the ones who will shine as bright as the sun in all the Creator's beauty and glory. This is the true value of a life. And I ask you my brothers and sisters, what is your potential?

Section 3

Age 19

My Path

9/2/10

Once, my greatest fear was death, but now I realize my greatest fear is to fail. From an early age it has been known to me that my purpose is to spread truth, love, and grace to all mankind.

 Now my problem is that there is no career for this. There is no earthly reward for putting a smile on a face, or loving and leading an enslaved soul to freedom. Love has shown me my path, and now I choose to walk it, regardless. I've learned not to stray from my path, but to keep moving forward and through the Creator's promise. I know the rest will fall into place.

It is time for me to gather and herd his sheep, and allow love to lead us to victory against the tyranny and slavery of the mind that rules our world today. Although I am in no position to call in the win, I know the battle will be won for Him. I know my path – do not be afraid to walk yours.

Quick Thoughts

9/02/10

When you begin to believe that you are better than the person next to you, that's when you become the lesser of the two.

Happiness is only an emotion, but joy is eternal and comes from love.

When I look into the sky in all its wonder and stare at the trees, I notice that all are alike and yet different in every way. I appreciate the beauty of life – when I stare into her eyes and see the love in them, it reminds me that Love created it all. The life that Love created in all of its mystery is beautiful and just.

It is all just, for me.

If anyone ever harms you or wrongs you, show them love, for that is your greatest weapon.

Long for glory, but not of this world or the people of this world, for that will come and die. To glorify the Creator will last you an eternity.

Do all good things today, for tomorrow may be too late.

Promises

9/6/10

Even though I messed up big time, I know I should've stopped doing all of those things I promised I would. I should've made a change sooner. I know that it's never too late to pick up the pieces, and yet I also know that giving someone space can't be the sole answer. I need to fix myself. I need to change; I'm going to keep waiting on the Lord. I know He's going to come through for me. Even though I might have lost my love, I refuse to lose my faith. My spirit will not be broken.

Thoughts of a Prince

By: Ja'Quintin Means

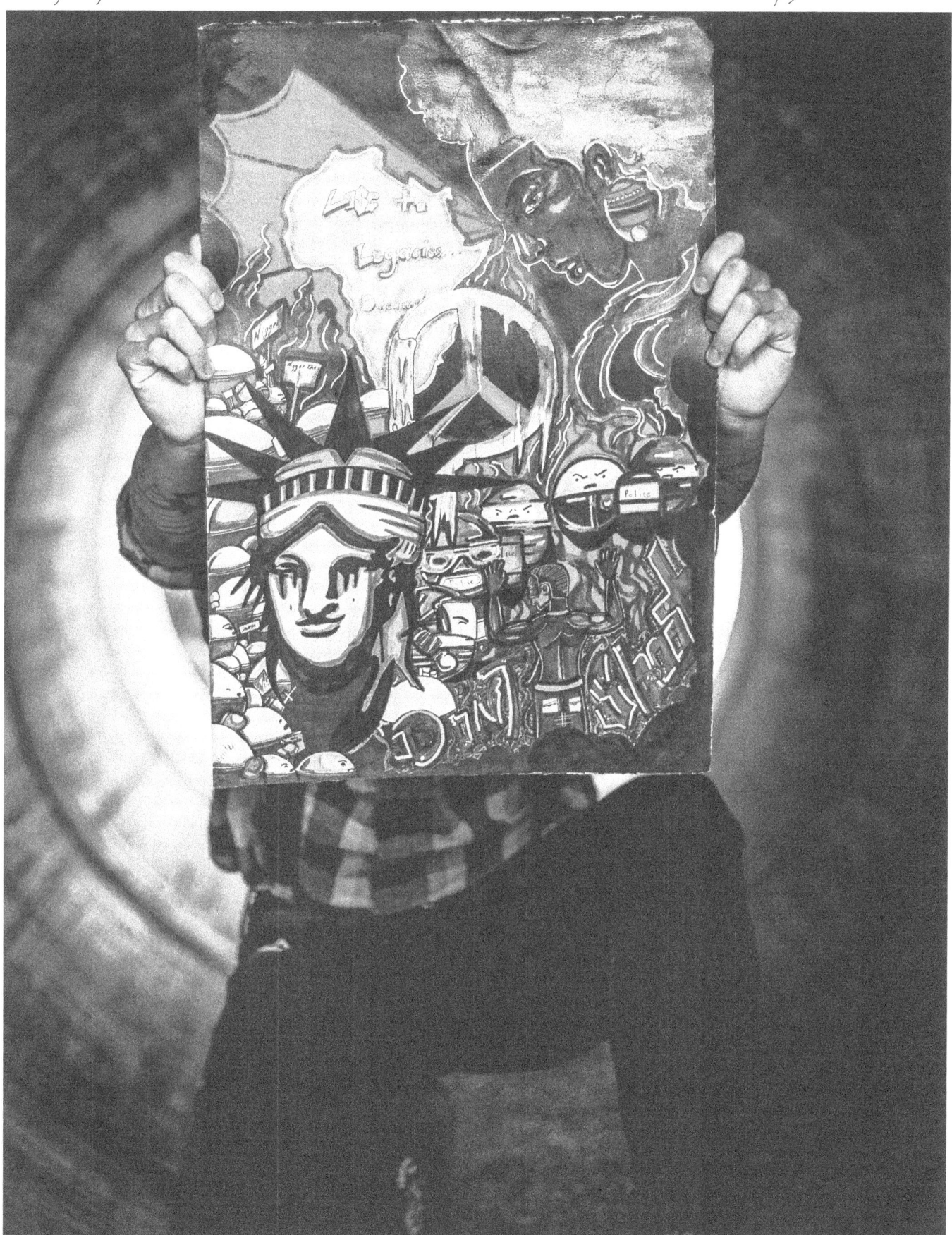

'So-Called Land'

11/03/10

America, the so-called land of the free, is actually the home of the enslaved. We are slaves to celebrities, music, television, the lies of politics, and the stories of priests and religion. We no longer seek the truth. We take what we hear, call it truth, and search no more.

Yet, we are hungry. We're hungry for our true selves, hungry for justice, and hungry for each other. Now is the time for our generation to come together. Now is the time for us to claim our birthright, and to be the change.

It is time for truth now. It's time to teach what life is worth, how beautiful it is, and what it truly means to be a light-bearer and a true lover of the Creator and your neighbor.

A Strong Man

11/04/10

A strong man has the body of a soldier, the mind of a king, and the heart of a lion.

This means you have the strength and power to fight for what you believe in. You make decisions and base your values on the welfare of the people of the world first, and yourself and your life second. Last but not least, you have the courage to stand up for what you believe in, to stare evil in the face, and to set captives free.

Thoughts of a Prince
By: Ja'Quintin Means

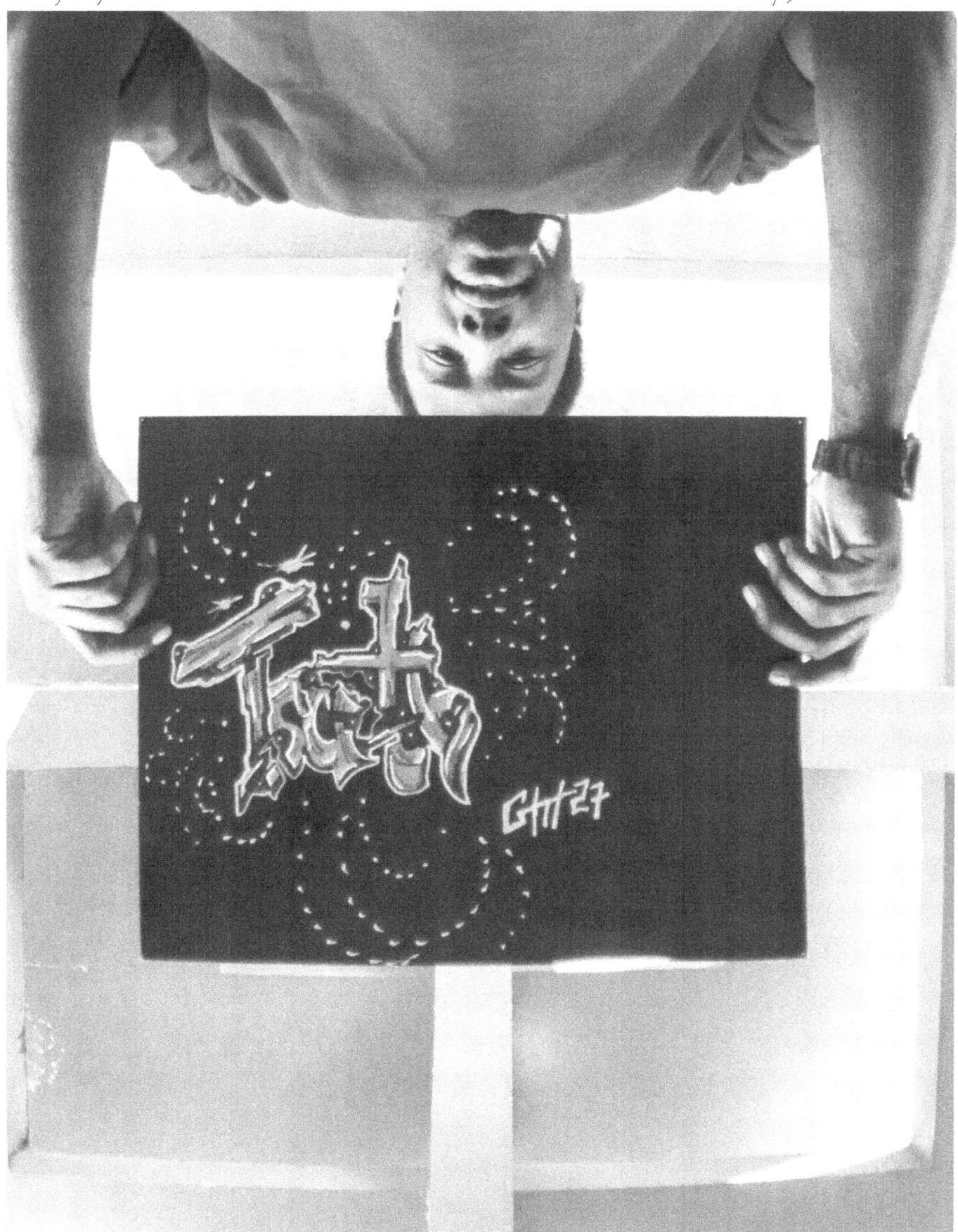

Find or Lose

11/15/10

How can you lose something that has never been found? How can you teach without knowing the lesson? How do you save a nation of people that have no idea they're in danger? The answer is the truth, but what is truth?

The truth is the healing of the soul. The soul holds all the answers for truth. Stop listening to men or to the rulers of the land. Rather, listen to the voices that we all hear whispering in our hearts from inside.

You can save the soul and reveal the truth that is found in love, peace, and joy. You will find the Creator in all of us. So stop running from yourself, turn off your TV, and listen to the truth as it transcends ego. Shine your light, take my hand, and let's move into our future.

Life

4/20/11

Love life. Life is a gift that cannot be explained. It is not owed to us, and we do not "deserve" it. Every single breath we take is a gift that cannot be given back. The only way to pay back the Creator is by dedicating your life to the betterment of the world and to living a righteous life. Treat every person you come into contact with respect, love, understanding, and compassion. You are no better than any person or living thing, nor are they any better than you.

Everything comes from love, and everything is love. If love were to no longer exist, we would no longer live.

It's Time

4/20/11

The time is now to take a stand. The time is now to fight back. The time is now to set aside your man-made fear and weakness, and to step into your destiny. What are you waiting for? Are you all just followers and do nothing but march to the drums of your makeshift masters? Have you all forgotten so quickly who your true master is? Have you forgotten who created us all? The things that you are so willing to sell your soul for come and go with the wind. How have you fallen so fast? How did you forget who you really are?

What caused you people, my people, and the Creator's people, to become so weak-minded? No. No more. My people are not weak, and I will no longer sit back and watch them destroy themselves.

We will walk down the road of enlightenment and spiritual prosperity.

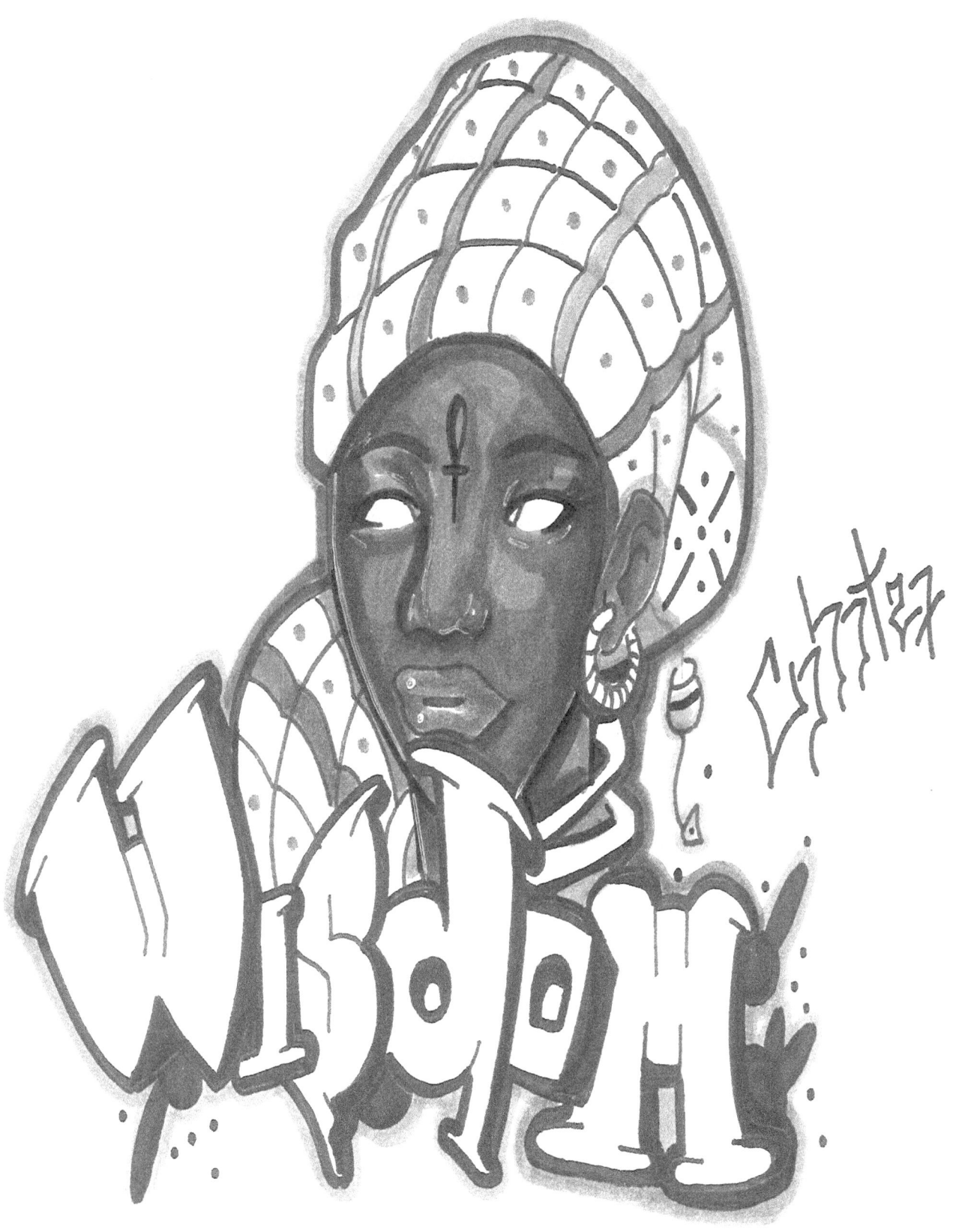

Food for Thought

5/12/11

Love

1. Love is the power that lives in everything. It is the love of the Creator that wakes us up every morning and gives us the strength to make it through our day-to-day trials and tribulations.

2. Love is in the beauty of the world and can be seen in all aspects of life. It can be as simple as a grasshopper feeding on a blade of grass, or as deep as a sacrifice in the name of peace. May we live life to the fullest in perfect harmony with God and the world.

3. Love is shown when you are caring, understanding, and compassionate to those who mistreat you and rise up against you. Love is a random act of kindness to a stranger when no one is looking – a moment when you receive no material reward from this world, no glory – just the satisfaction of helping your brother or sister in need.

4. Love is being open-minded and not judging those you come into contact with.

It is living with the understanding that we all are created as different individuals and yet equal, and that no person's decisions or situation deserves your criticism or disrespect.

5. Love is everywhere and everything, so love all, and stay connected with the Creator so that the people will see the spirit of God in you.

That spirit will shine,

and the love will spread throughout the world.

War

1. War is ignoring and neglecting the value of the human life.

2. War is what happens when man-made hatred, fear, and pride are combined with the unwillingness to understand and compromise.

3. War is the belief that one religion, race, or culture is inferior to another, resulting in a group that feels the need to dominate, control, and destroy for material and selfish gain.

4. War cannot always be avoided, because sometimes you must defend your life and the lives of all those around you. In this case, you fight but do not fight to end up in a vengeful death,
but as one trying to make a way for life, peace, and freedom.

5. The rich start wars and sit behind their fake reasons. They rest on their golden thrones and watch the poor fight and die for their sins,

while they brainwash the weak and destroy and conquer all that is good. So be careful before you follow your leader to war.

Be slow to act on anger.

Life is beautiful, and war is the destroyer of beauty.

Wisdom

1. Wisdom is knowing to do good in all things and the strength to use it.
2. Wisdom has no ties to age, education, or material accumulation.
3. Wisdom is earned through the trials of life, and is gained through the accumulation of experience and knowledge.

Wisdom is shown through understanding, love, and the strength of character.

4. Wisdom is being quick to act righteously and slow to react in hatred and rage.
5. Wisdom knows that everything is connected, and everything is love. We live through love and for love. It is the realization that we are so small, and yet so very important. It knows that you are responsible for the choices you make and that those choices have negative and positive effects. Wisdom is knowing that everything in life happens for a reason and that you're always exactly where you are supposed to be.

6. Wisdom is to be shared. If not, it is just wasted, useless knowledge.

Thoughts of a Prince

By: Ja'Quintin Means

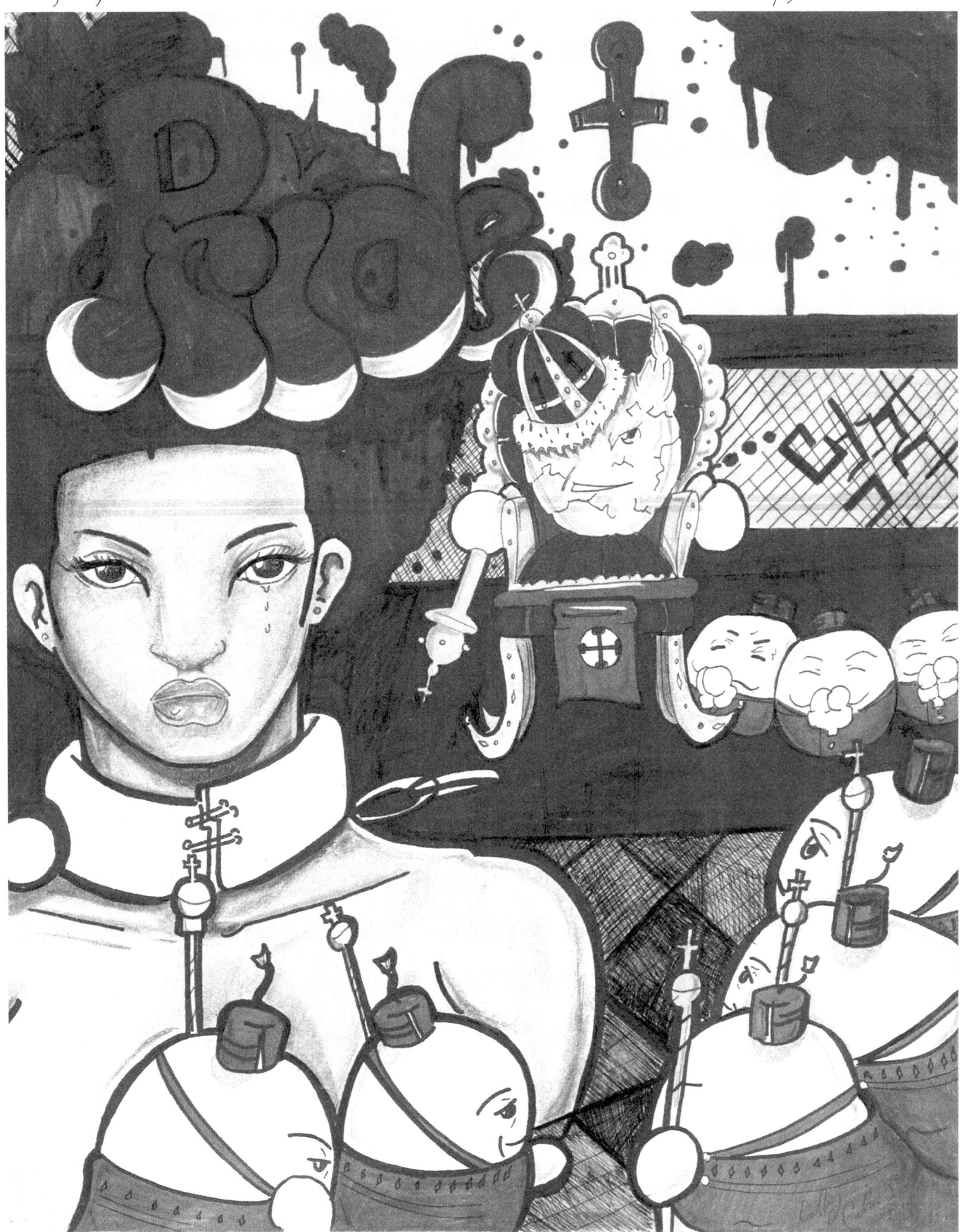

End Times

5/20/11

Reject all false witness; beware of the tricksters and false prophets. They will scare you into believing their words, and they will frighten you and use your fear against you to cloud your mind. My friends, look beyond the pretty curtains, and read between the lines. How has man tricked you into believing that he is all-powerful and all-knowing? My brothers and sisters, do not stress. Listen to your heart and soul. Listen to what is good and true; refuse to be swayed by the media and makeshift fortunetellers. My brothers and sisters, do not worry about the future.

Live in the present, stay in the moment, love, care for those around you, and hug those who sin against you, including those who do you wrong and spit on you. Live strong and be righteous, so that when troubling days come, there will be no fear and no doubts – just the joy of leaving this material world of oppression behind and spending eternity in love, hand-in-hand with the Great Spirit.

Short Thoughts

7/5/11

How did I fall so far from my Lord our God how did I lose myself so fast? Why did I let the influence of another man stand in the way of my love for Christ? Who am I now? What have I become? How do I get back to a better me? I give my body back to you, my soul is yours, please fill me with your spirit again Lord. I'm sorry I strained away from teaching your words of love.

Section 4

Age 22

Sometimes

8/16/13

Sometimes the Great Spirit creates good, yet we see pain and confusion. We get mad and curse Great Spirit when we forget the plans it has made for us. If we listen, it tells us to be strong and courageous, and not to be dismayed for Spirit is with us.

Sometimes though, as soon as we face the smallest obstacle, we run from our destiny. We get lost in trying to be the boss and trying to control situations that are completely out of our hands.

You are never alone, so be strong and have hope. Don't do wrong to get ahead nor fold under pressure. Keep your head high and never let go of that light that gives life to us all.

Life is Love

8/16/13

To love is to care and understand. It lifts up the spirit of the earth. Love means progressing into a state of self-awareness and high self-worth. It means not judging a person by material standards, a practice we seem to let govern over what life truly is. Life is about the soul. Will your soul blossom or wither away?

Will you love or will you fear? The choice is yours to make. It is no longer up for debate. Please wake up. Who do you trust?

I live in my soul, and I give up all control I think I have. Call me crazy; I'll be breaking the mold.

Grace and Mercy

8/17/13

The grace and mercy of God is a beautiful sunset on a cool August night, bright with color that covers all. If you ask, God will comfort you. If you are faithful, Spirit will lead you. No need to beg or plea – just be honest, and Spirit will give you peace and company. God is a father to the poor ghetto boy on the corner. God is a shield for the weak, a mission for the strong, and a husband to all women left alone. Love is its name, and wisdom is its aim. Do not be frightened or scared. I promise you won't lose a hair – just be free, and I'll teach you how to fly like me.

Solitude

8/20/13

Solitude sets the mood for a talk and relationship with Great Spirit, who wants you alone, with no distractions or objections. Let Spirit soothe your fear and erase your doubt. Let Spirit be the loving parent and mentor that orchestrates everything. Feel it breathing and living inside of you. Let the fire that builds inside grow as you weave your way through this dark and corrupt world. Lift up your voice. Praise Spirit with your thoughts, your speech, and your walk.

Do not allow your thoughts to be clouded with things that will live and die with the physical world. Strive to become light.

Thoughts of Her

8/22/13

Why do I still think of her? Why do images of her beauty and now past understanding mingle with remnants of old memories, cut short by lies, mistrust, disloyalty and betrayal?

I remember my weakness and willingness to convert to a false reality, where the people in charge both make and break the rules. This is the life I chose to live. Maybe she isn't for me. Maybe she is a lesson to show me the way things are supposed to be – to grasp the strength that was placed inside of me, to step deeper into my destiny.

No longer restrained by the frame the rulers of the world try to lay out for me, I know my destiny.

The rest I will have to wait and see.

Relationship

8/23/13

What is love between a man and a woman? Does true love ever fade, even from a distance of a thousand miles? I still feel I can communicate with you through the beating of my heart and the meditation of my soul. I feel you yearning for my touch and to see my face once again. I hear your voice in my ear. I feel your compassion as you reach to hold me and care for me. The way I seek you and search for you is the way the Creator yearns to love us.

"If you choose to accept my love," Spirit whispers, "I'll teach you to love one another."

Hindrance

10/10/13

God, let nothing hinder the plans you have for my life, nor for your people. I pray that you do not allow my fear of not being accepted, of hatred, and of slander get in the way of the calling you have for my life. Fill me with your great spirit. Keep me close in your presence. Keep me strong, with my eye fixed on you. Do not allow my ego to stand in the way between my destiny and me. Do not allow my shortcomings of lust, fear, and pride block my way of growth and inner peace. Oh Spirit, save me from myself, so that your people may see an image of your love.

Through your people let the river of life glide like leaves in the wind. Through your people let your gifts of mercy and love be shared throughout all the earth. Allow this generation to call on your name in their own way. Oh God, how have they forgotten your teachings and words, even while reading them aloud? Great Spirit, they have led many astray. They have killed others and themselves in your name. Come down to us, use us, God, that we may feel the light of your love, which carries us back to your arms. Sacrifice me so that we may be free.

Creation and Expression

12/9/13

The soul is the essence of life, filled with seasons of creation and expression. We must learn to fill our spirits with love, justice, and mercy. We are our brothers' and sisters' keepers, and yet we learn to live in the physical world where we do not seek to feed our souls. Grace is a gift that belongs to those who choose to accept it. It cannot be taken from you, nor can you give it away. Learn to be brave, strong, and to persevere. Learn to have compassion for the weak and to fight for those who cannot fight for themselves. The world is your family – Spirit the father, and Earth the mother.

Beauty

12/10/13

They say beauty is in the eye of the beholder. I see now that they mean physical beauty, only skin deep, which fades away like the setting of the sun. What is true beauty? What is the beauty of the soul? Beauty lasts; it is ageless. Fire cannot burn it, knives cannot cut it, violence cannot destroy it, and the injustices of society cannot corrupt it. The beauty of this life evident in the eyes of those who believe that life is beautiful and in those who choose to trust in the loyal steps of love. They choose to open their eyes to see in creation that there is both light and darkness, both joy and pain.

Beauty is in the eyes of those who care for their brothers and sisters. Beauty lies in the souls of those who love beyond religion, race, and social status. This true radiant beauty lies in the heartfelt actions of mankind. Take hold of it and allow it to spread, so that true beauty may save every human heart.

Evolve

1/4/14

The strength of thought evolves out of not only freedom of thought, but also from the hardships of life and the struggle against corrupt leaders of religion and politics (that has usually ended up in death or excommunication of those that speak up). Reform is a consistent struggle between new and improved ideas and old superstition and rituals. The beauty and growth involved in both pain and prosperity invokes a new way of thinking for people and further enhances their understanding of universal truth, love, and wisdom.

Thoughts of a Prince By: Ja'Quintin Means

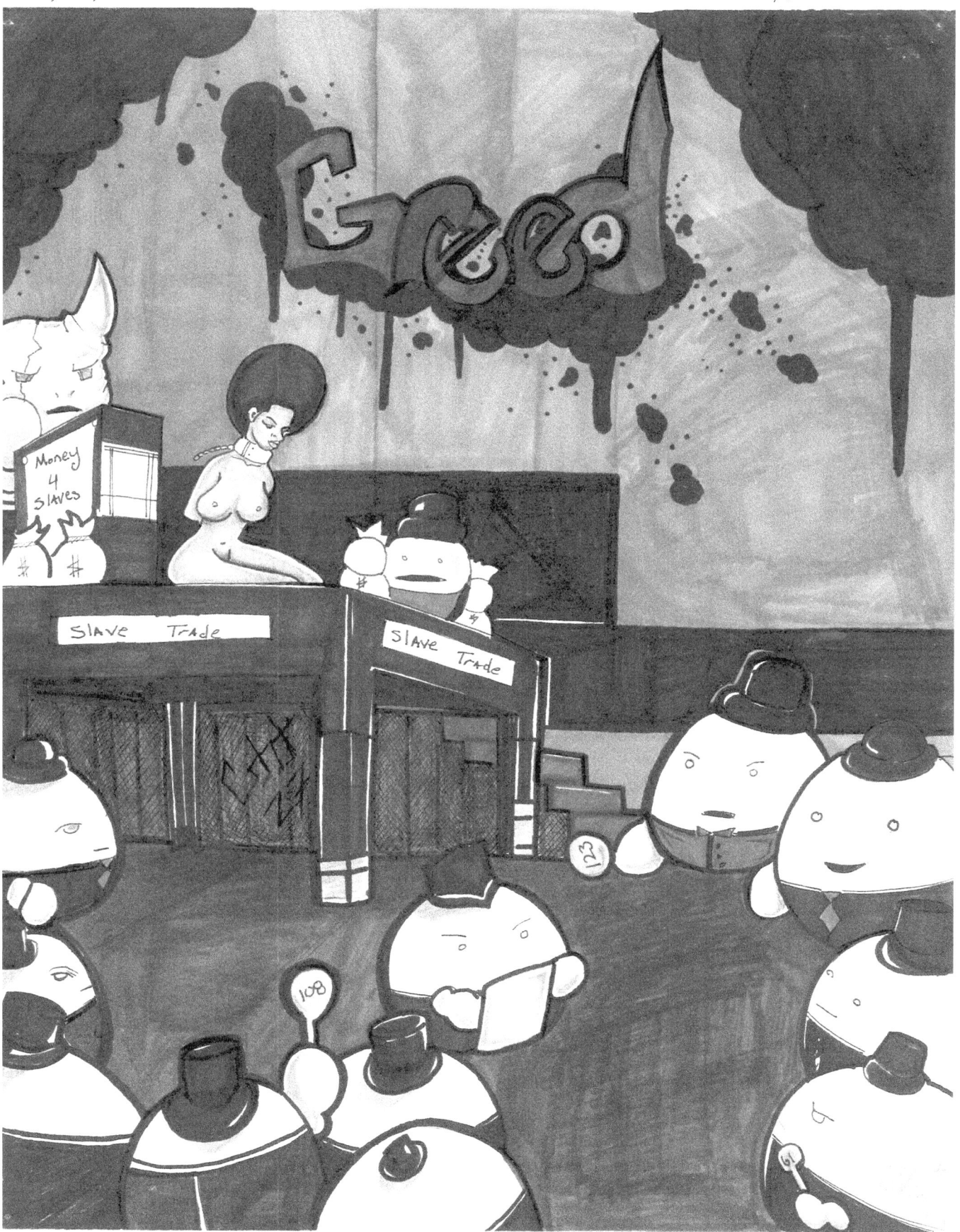

Complete Control

1/4/14

The desire to unify a country through mainstream culture and religion can form unnatural separation among its citizens. This weakens the country, in terms of spiritual freedom and openness. It causes a period of stagnant idealism and the decline of action for justice.

The power of faith and patriotism can be manipulated by the hands of rulers for more political control and to demand loyalty from its citizens. Think back to the Spanish Inquisition.

This period of violent practices was used to threaten and beat people of other faiths and cultures into submission to the crown and the Catholic Church. The Inquisition forced all citizens in the region of Aragon to either take up the Christian faith or flee the country. This placed people in a state of constant fear of the monarchy. They feared to speak out against their rulers. They were forced to follow a church faith and its systems, under the threat of being burned for heresy or beheaded for treason. What would Spain look like today if the Inquisition had never occurred?

Class Thoughts

1/6/14

Mercy is an act of love. It includes the washing away of regret and self-inflicted pain, replaced by the rejoicing of a covenant that has started anew. There is no end to mercy, as along as you are humble and honest with yourself. Constantly healing yourself and growing in love day by day makes you stronger and closer to spiritual excellence.

Mercy is not limited to one group of people, rather to all humans. It is a heart-gift from the creator of life, and it connects spirit to all living things. It can never be abused nor can it run out.

Only an honest and humble heart can truly receive mercy, or understand the context in which it is given. Mercy, love, grace, compassion, and wisdom are all different members of the same body of creation. One does not exist without the others.

Thoughts of a Prince

By: Ja'Quintin Means

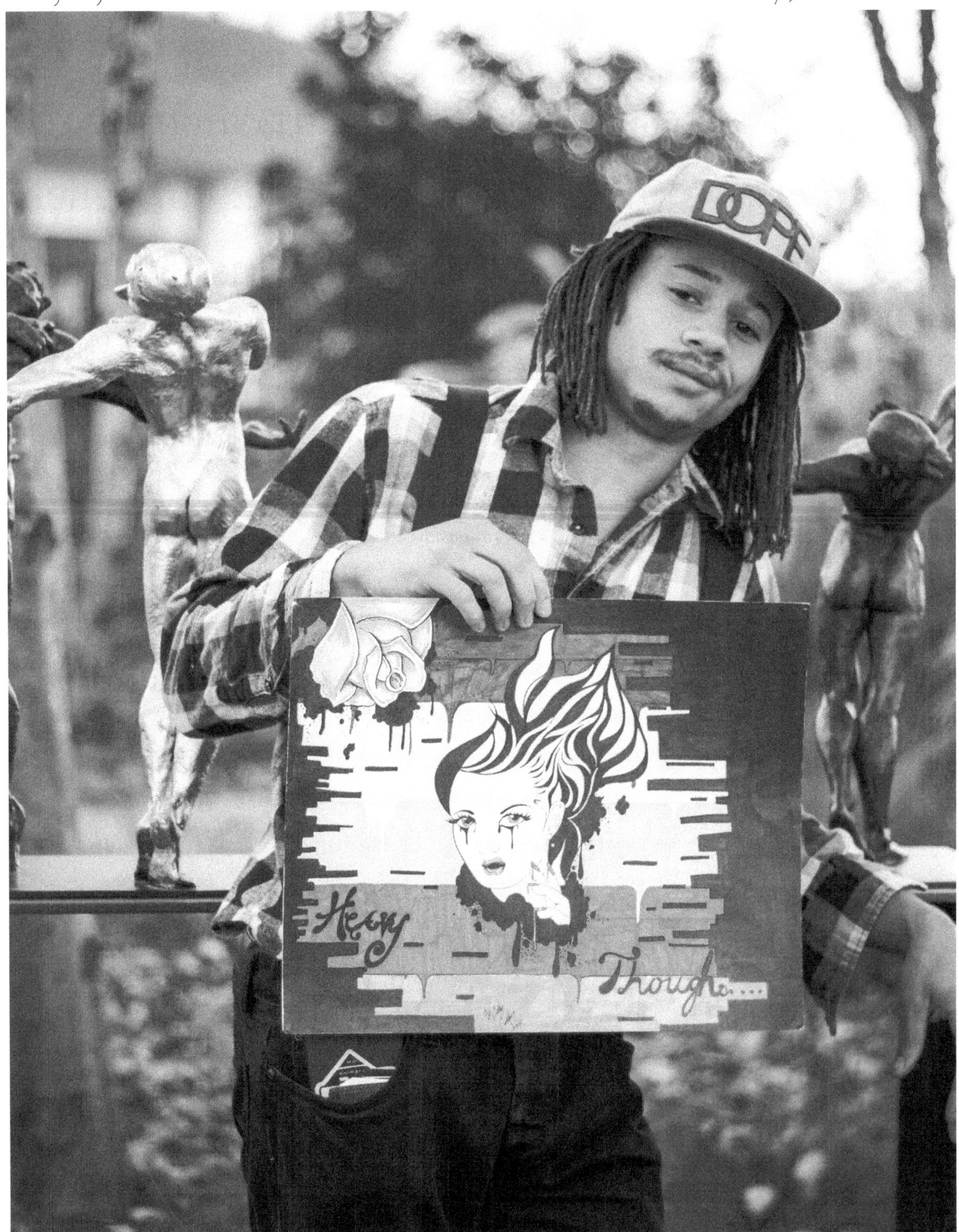

Late Night Ponderings

12:42 a.m. 1/17/14

The story was told. I watched and saw all the strong give in and fold. The world is a scary place, but the weak can grow up to win the race.

Will you fold or stand? Is it clear to yourself even whether you support oppression, or whether you refuse to be a slave? Choose wisely. You have been blinded by the lies of black suits and ties. Don't try to hide – strive to find the light that lives inside. There's beauty out here; wake up and see.

Fresh Breath

1/21/14

Life is a breath of fresh air, which allows us to see and feel the world around us. It's the joy of companionship. It's the pain and pressure of leaning and falling. It's the gift of grace and the spirit of love. In a world of self-inflicted struggle and chaos, we have lost our way. Today is the day that we change. We are brave, and we refuse to be slaves to the unhealthy pleasures we crave. No longer will we lie and steal from our brothers. We have a new life of joy and grace; we will finish the race, where we only win if we give up first place… so that we may save the human race.

We are all family – even those holding signs of need on the street. They need peace of mind, so much sweeter than wine. Isn't it divine the times we broke the chains and learned to fly? The world is ours for the taking if we shed our pride and choose to be naked. Don't take long – our destiny is waiting.

Nothing Better

1/21/14

There is no better thing than love. Love heals, love is strength, and love is grace. What is grace? Is it something we can touch and feel?

Grace is forgiveness. We do not own it; we cannot take away someone's perception of it. It is a gift, received through pain and loss of pure flesh and blood. It is abundant life. It inspires change and moves people toward spiritual freedom. You must have an open heart to receive it, and once you internalize its power, there is nothing you cannot achieve. Grace is like an abandoned baby left on your doorstep.

You have the choice to open up your heart to allow it into your life, or slam the door.

The Universe

2/2/14

The universe contains this realm of existence we embody as physical human beings. The universe and everything on this side of the realm of material embodiment carries the living spirit of the creator of all life and energy. Life is only sustained by a living host of a physical body: flowers, trees, animals, insects, water, and elements carry not only the spirit of life, but also a spirit of creation. We are every bit a creation of the God that resides in a spiritual realm. Beyond our physical existence lies an eternity of life, energy and fullness of creation.

The Choice

2/3/14

To indeed be free is a choice that lives in the heart of every human being. To be strong, courageous, and fearless is our deepest desire. To feel love, be joyful, and grow is our reward. We are lost beings of greatness marching down a path of darkness, terrified to find out how truly powerful we are. Our greatest stumbling block is the self's perception of others and the world we are learning to live in. It is our ego, which we have unknowingly nurtured for self-interest. This leaves us secluded and separated from the human family that we desperately need to survive and thrive.

To be free is to understand the truth of all existence. It is to understand how much we love and need one another. It lies in the connection and the foundation all things that exist.

Duality

2/21/14

What is joy without the knowledge of pain and suffering? What is strength without weakness? The essence of being is acknowledgment of the duality, yet oneness, of life.

Doubt is what hinders us from becoming the great beings we dream of becoming. We have to learn to dig deeper into our souls to reach the things we thought impossible. The power of creating a life of abundance and receiving the fruits of goodness our hearts desire is at our fingertips, if we only choose to believe and claim our perfect destiny.

What You Have Given Me

2/23/14

Thank you for all you have given me. Cure me of my disbelief; allow me to be pure in my mind. I am grateful for your great work. You place upon my life all power and authority, which has been placed in the human heart and flows through my spirit. Do not lead me away from your path, and save me from my own shortcomings. They distract me from the true purpose of your will. Allow my soul to cry out for a better tomorrow.

Sweet Dreaming

3/7/14

The beauty of a dream that screams from underneath the fabric of our imagination is in its truth. This truth flows from the heart and triggers expansion of the human mind. A divine spirit of existence lingers under the mist of a painted false reality. The dream feels so real to me that the taste fills my mouth with the sweetness of destiny. The aroma of fulfilled promise awakens me into considering a life of unspoken possibility. I want to swim in a river of spiritual prosperity.

The filth of a dark world will be ripped clean in the rays of a guiding light so bright that it draws the attention of the world. The greatness of life will be evident through an interaction between you and me. The loving passion of people will be lost in a sea of sweet and everlasting peace. This is the beginning of tomorrow. Follow your dreams. What do you adhere to? Is it self-preservation and ideology? Or is it a foundation so strong the wall can never be breached?

Perhaps you believe the fear-talk, like that which fills my mind from time to time. Sometimes I think that my supposed power is too inadequate to fulfill my purpose, which makes me feel worthless. These inferior feelings may come and commandeer the things I hold dear. I choose to hang on until the plan becomes clear.

The Spirit

3/9/14

The spirit of the Creator moves wherever love sends it. Whether in a still calmness or a screeching cry, it reaches the ears of the soul. Beauty and greatness are its rewards. Love and peace are its gift. Strength and courage are its prize. It is the fulfillment of the soul, the essence of a life unseen and words of sweet wisdom unspoken. It is what turns a flickering candlelight into a burning flame that cleans the soul, rippling out from the heart.

Alive

3/14/14

Thoughts of decaying bread contrast with those of becoming alive. The spirit can lay dormant inside your dulled eyes, waiting for revival. Lost tidings of the spiritually blind can evolve into a purpose-filled life. Seemingly unending in a system of drug battles and pirates, the smudges of bloody fingerprints can be washed away. Realize that your enemy was never your rival, rather the lies and false hope cultivated inside of you. Then you will see the divine helping hand reaching in to lead your spirit to a land in your mind called golden humanity, heaven on Earth.

Constraints of Fear

3/16/14

There is greatness that lives underneath the constraints of fear. There is a spirit of truth that flows from the mouth of those who accept and nurture the spirit of the Creator. There is abundance in the foundation of life that flows like a great river, found in the light in the eyes of every man and woman. There is an unspeakable amount of joy and peace that resides in the heart of those who keep faith and watch as the Creator speaks through our lives. For words invoke thought, and thought invokes action –

thereby the potential and work of the soul manifests. This is the glory of the Creator: that we love and care for mankind, and protect the pureness that connects all life in the world. Purity will stretch into eternity and surpass all worldly thought and imagination.

Slavery

5/7/14

A slave is not always literally locked down with locks and keys. Slavery can also be a spiritual state of unawareness. Being a slave is being trapped inside of your own soul. It's when you are unable to manifest the full existence of the spirit of love and truth that is mankind's birthright.

This type of slavery binds you with the chains of your patterns of not forgiving. It binds you with your dividing mentality, keeping your group divided from the rest of the human race. It is the holding on to someone else's opinion of you. We are slaves to the dictates of society.

what is okay to do, think, and believe.

There is a subconscious fear of breaking free from these unseen, often unnoticed societal norms. Use your life to serve and love everyone around you, regardless of race, culture, religion, social-economic status, or political ideologies.

This is the only true way to gain your freedom.

Letter to My Unborn Son

1/11/16

My son, be good. This is your destiny. Your purpose, my son, is to love and to spread that love at all costs. No, this world is not perfect. There will be times when it seems very dark, and you will think, "What is the point of it all?" I say to you: find the beauty that lives on our Mother Earth. Spend time alone in nature to find your peace and harmony. Witness the pure creation of God and all its wonder. This will help you spread the light that lives inside all things out into the darkness. Seek to be a burning torch in the abyss of hate and fear.

My son, I am not perfect, and I pray that you will learn from my mistakes. I know that you will teach me to be a better man. I hope that one day you will lead me to a better tomorrow, and that you will be a mirror to the depths of my soul. My son, nothing is impossible. Anything that you dream of doing in this life can be accomplished with hard work and dedication. You are powerful beyond measure – just know that the greatest enemy you will face will not be from an outside force, rather from your own reflection in the mirror.

You must learn to conquer your fear and weakness, so others may learn to do the same. I love you, my son, and one day when you have a child I hope that you remember this letter and guide them as I am guiding you now.

Until you arrive I will be here waiting to see your beautiful face.

The End

www.ingramcontent.com/pod-product-compliance
Lightning Source LLC
Chambersburg PA
CBHW080659190526
45169CB00006B/2178